BROTHERS: BEST FRIENDS GROWING UP

Sherry Ramrattan Smith and Benjamin Eric Smith

AuthorHouse™
1663 Liberty Drive
Bloomington, IN 47403
www.authorhouse.com
Phone: 1-800-839-8640

First published by AuthorHouse 1/18/2010

ISBN: 978-1-4490-6339-9 (sc)

Library of Congress Control Number: 2009913915

Printed in the United States of America
Bloomington, Indiana

This book is printed on acid-free paper.

authorHOUSE®

For

Matthew Brian Smith

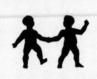

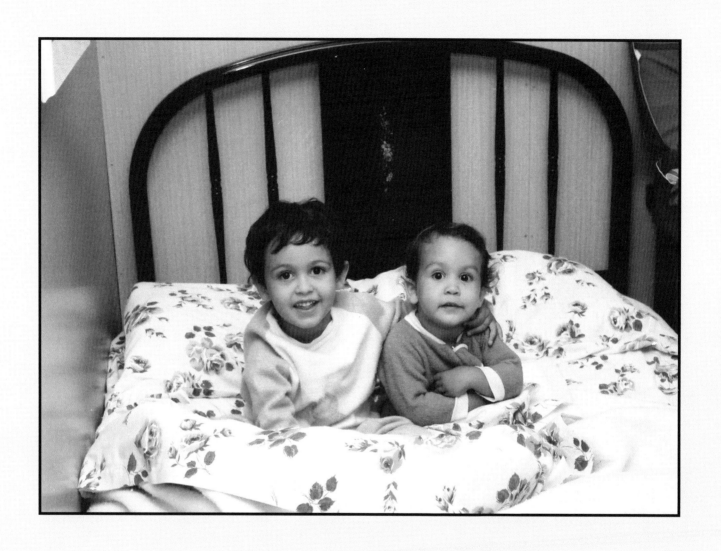

My brother is my best friend.
I tell him stories at bedtime.

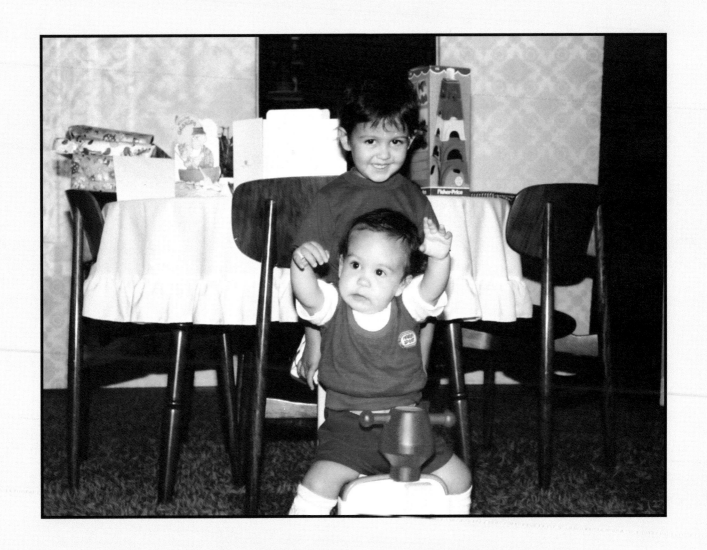

We celebrate my brother's
first birthday together.
He has a new train.

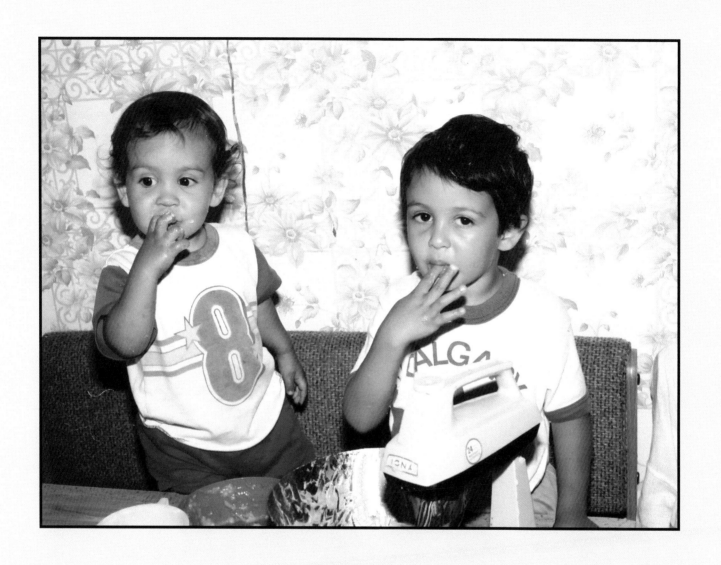

We help to make cookies.
First we taste the cookie dough.

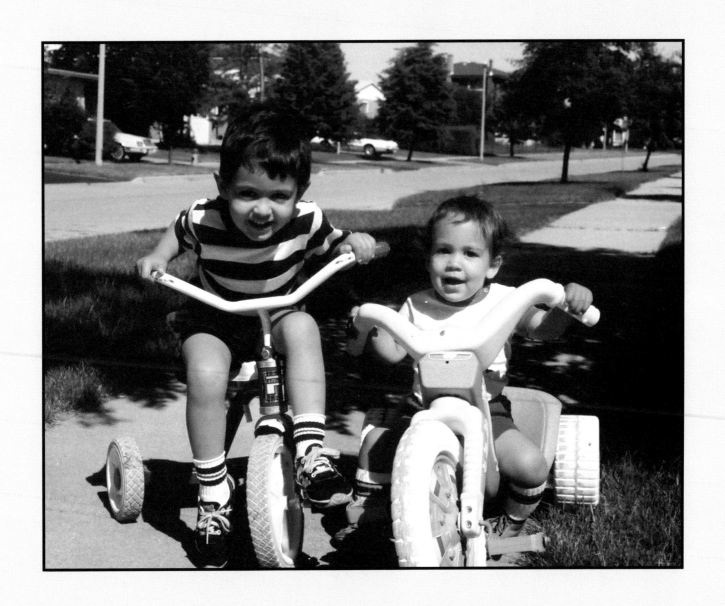

We ride our bikes together.
We are fast!

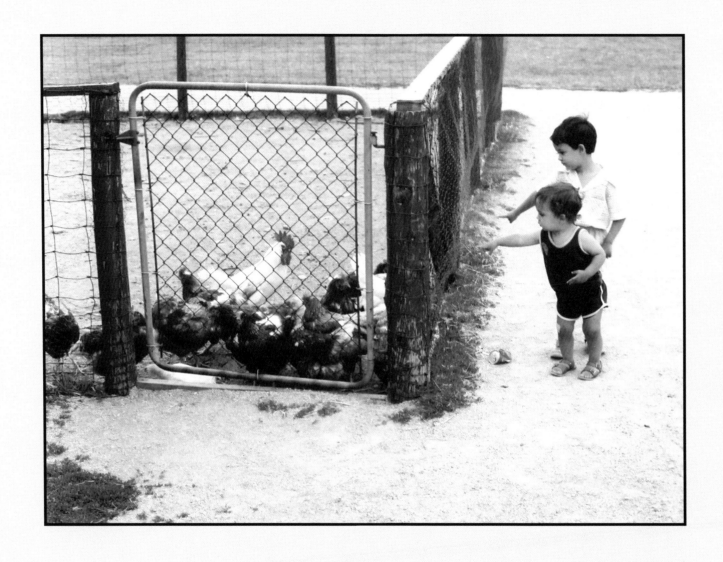

My brother and I watch the chickens.
They make clucking sounds.

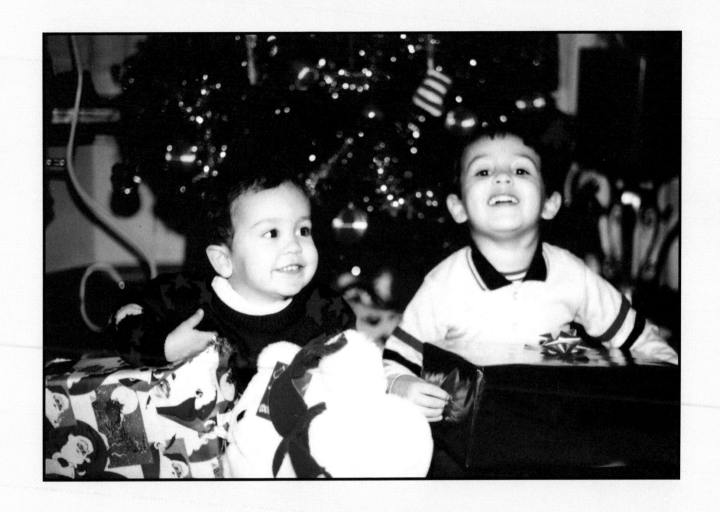

We celebrate Christmas together.
There are lots of nice presents.

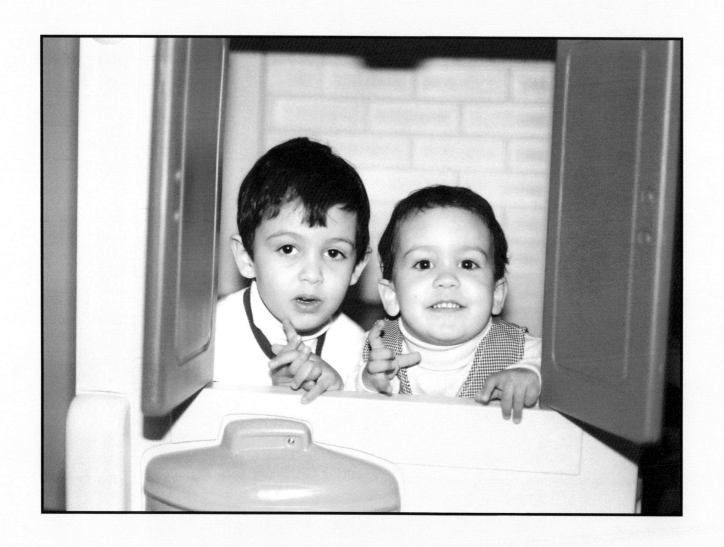

Sometimes we play in our playhouse.
We make up stories.

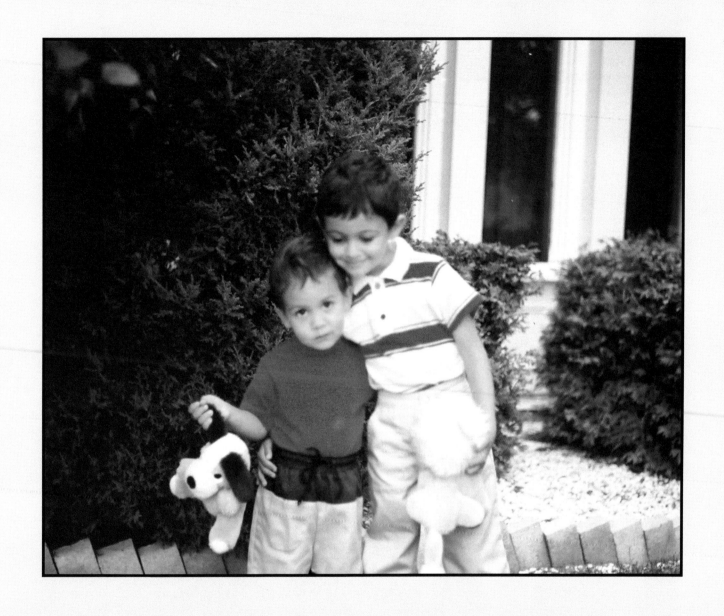

When my brother is sad, I help
him to feel happy again.

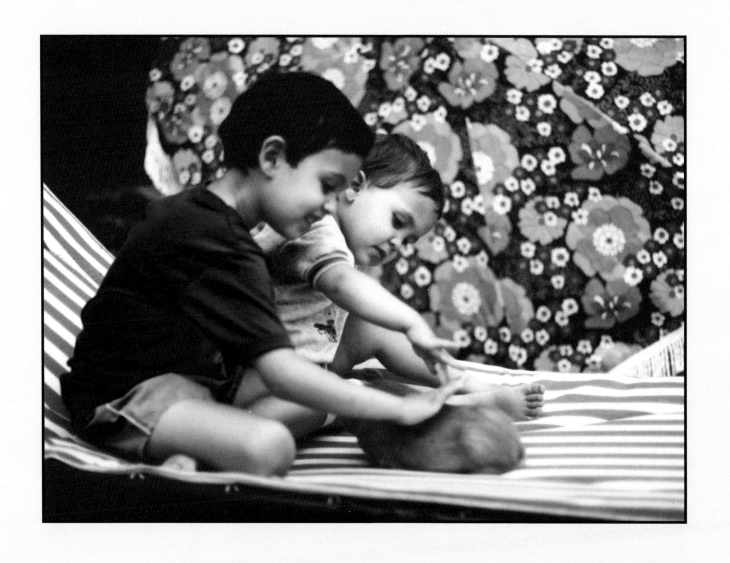

We play with a guinea pig.
We are very gentle so we don't scare him.

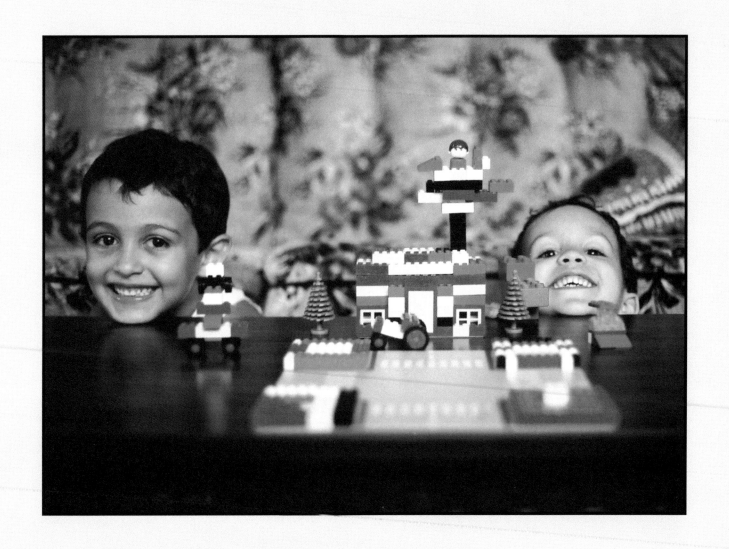

We like to build with Lego.
We are so happy!

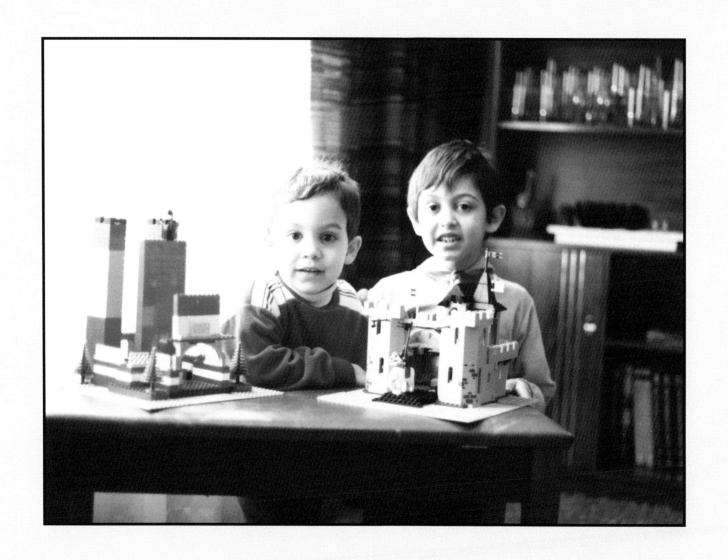

We build a castle and an apartment building.

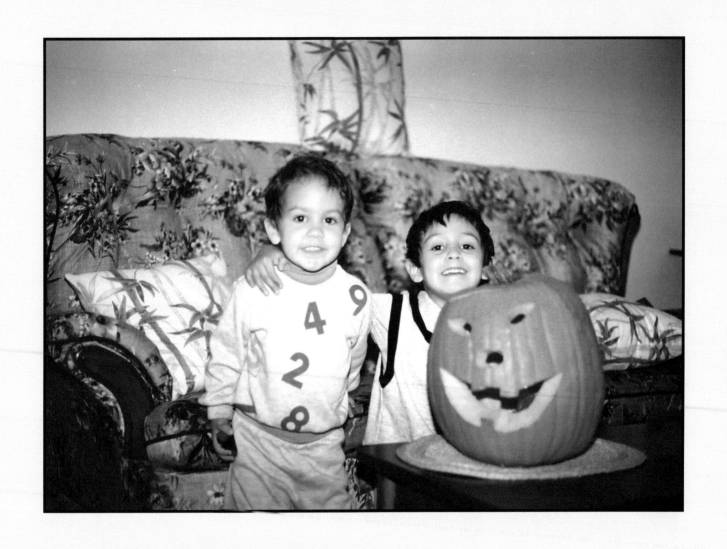

We carve a jack-o-lantern for Halloween.
It is scary.

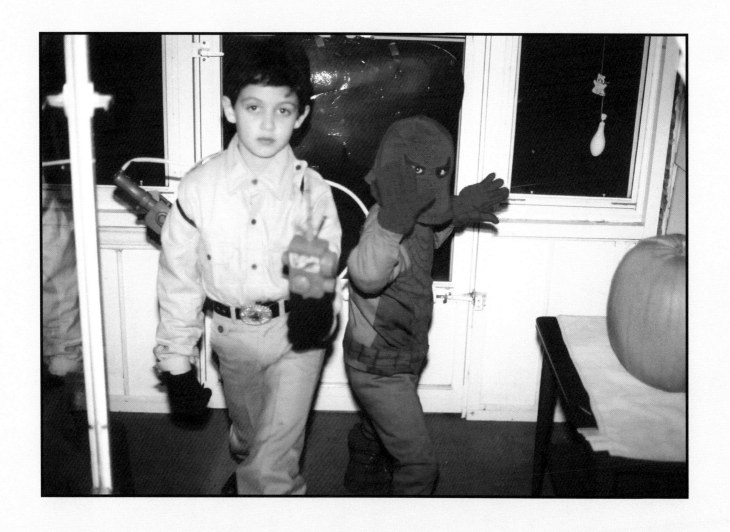

I am a Ghostbuster.
My brother is Spiderman.
We go out to collect treats.

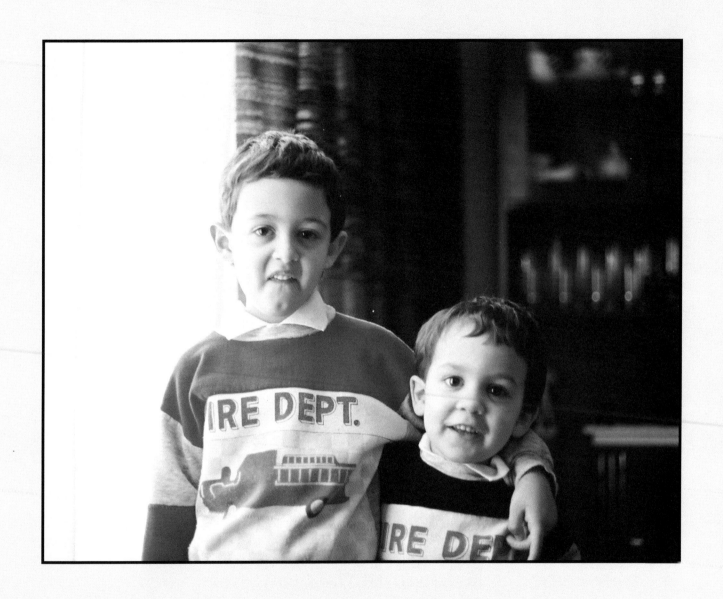

We are brave and strong firefighters.
We help people.

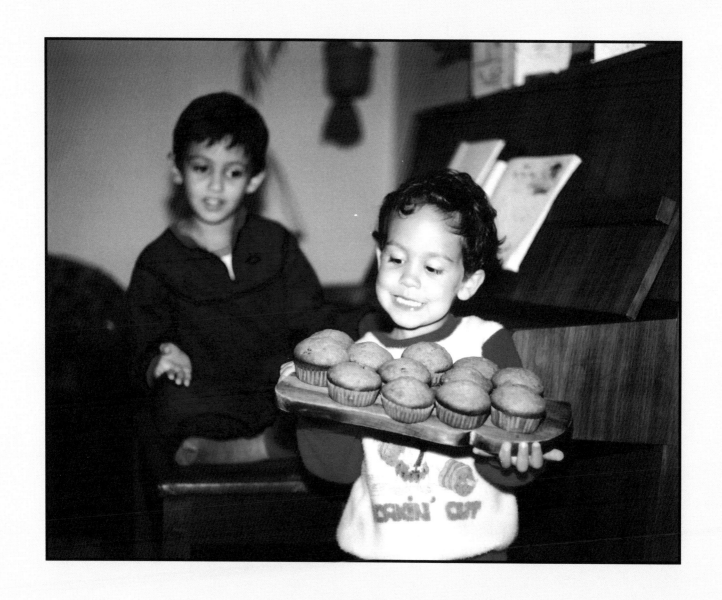

My brother is a baker.
He is proud of the muffins we made.

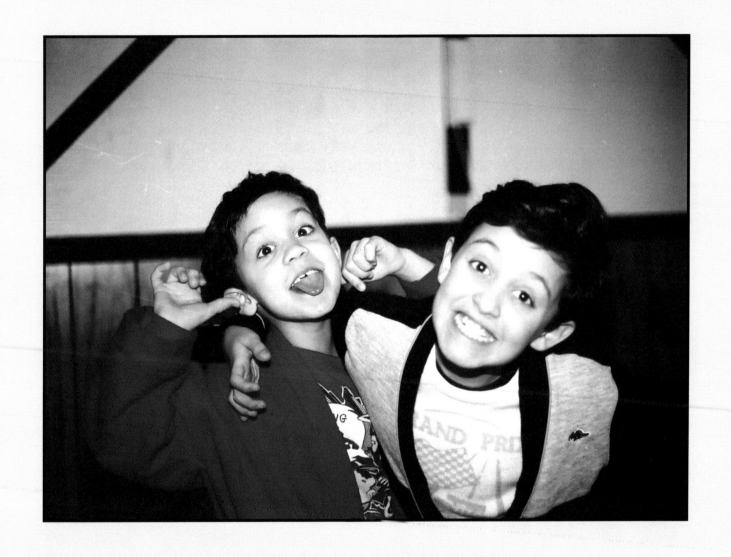

Sometimes we act silly.
We make people laugh.

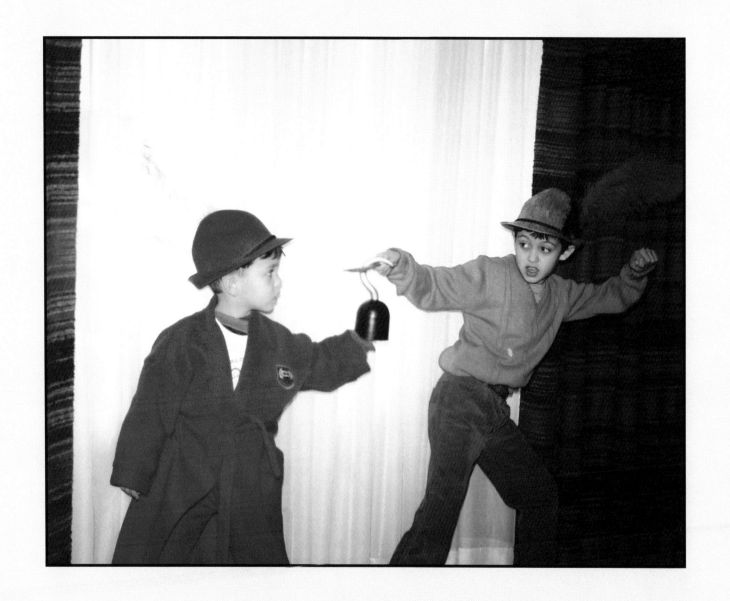

At night we act out Peter Pan.
Our family enjoys the show.

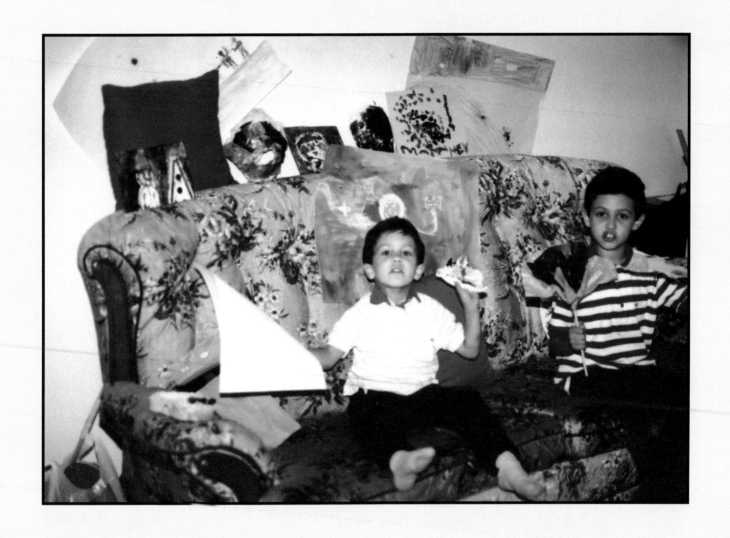

On the last day of school, we bring home our school work and invite our family to see it.

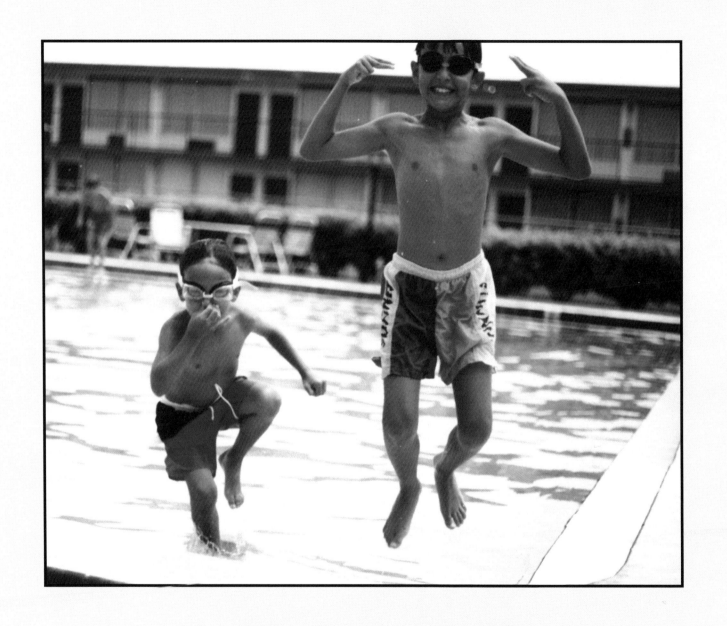

Hurray for summer!
We have fun in the swimming pool.

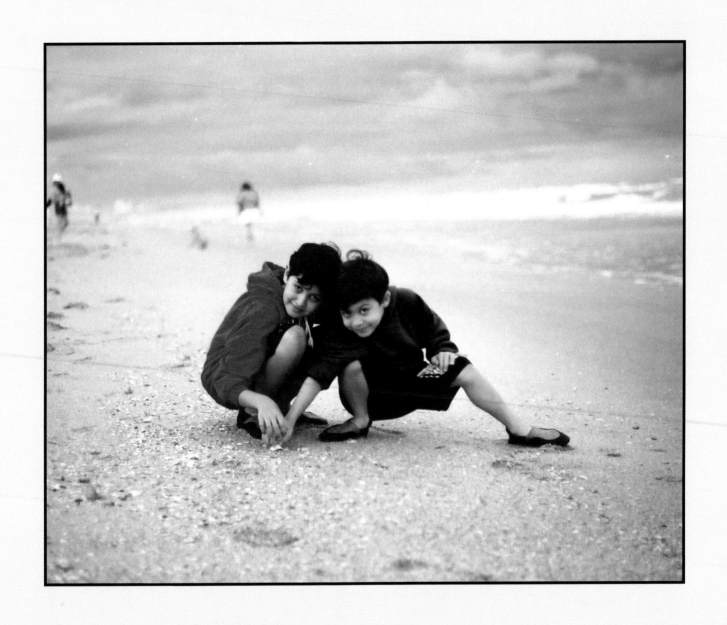

We collect shells on the beach.
Even when it's cloudy, we have fun!

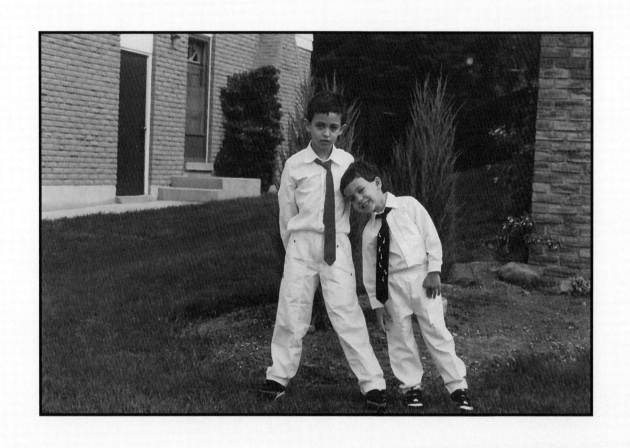

My brother and I are like the movie, "Twins".
We are best friends growing up.

A CONSIDERATE CURRICULUM

Curriculum is about choices we make on a daily basis. *A Considerate Curriculum* encourages us to critically examine our actions and carefully consider how our interactions can support and nurture our children as they grow and learn.

LaVergne, TN USA
26 January 2010
170978LV00001B